A PORTRAIT OF THE ARTIST AS
A YOUNG CAT

THE LIFE and TIMES of ARTISTIC FELINES

BY NIA GOULD

CHRONICLE BOOKS
SAN FRANCISCO

For Olive, Kerry & Nova

Library of Congress Cataloging-in-Publication Data available.

ISBN: 978-1-4521-7838-7
Manufactured in China.

Design by Kayla Ferriera.

10 9 8 7 6 5 4 3 2 1

Chronicle books and gifts are available at special quantity
discounts to corporations, professional associations, literacy
programs, and other organizations. For details and discount
information, please contact our corporate/premiums department
at corporatesales@chroniclebooks.com or at 1-800-759-0190.

Chronicle Books LLC
680 Second Street
San Francisco, California 94107
www.chroniclebooks.com

CONTENTS

BARBARA CATWORTH

1903–1975

Barbara Catworth was a nature-loving cat whose influential sculptural work was largely inspired by the organic shapes she saw in her surrounding landscape.

Her closest friend and rival was fellow student Henry Meowre. As students they both became well-known for the direct carving sculptural method, where the artist consciously respects the nature of the material. Their shared interest in organic form and materials led to both mutual admiration and occasional hissing over the similarities in their work.

Early in her career Catworth spent some time traveling around Europe with her husband, Ben Nicatson. She visited the studios of some of Europe's most influential artists and made many friends in her nine lives including Pablo Picatso, Piet Meowdrian, and Catstantin Brancusi. During this time, she sharpened her claws and her skills on different materials such as wood, stone, plaster, bronze, and marble. Circles and spheres dominated her work during this phase (many cats so love a ball); later she started creating ovals with two centers, and thus a more complicated form. This

visit proved to be extremely important in her career; she had gained a set of highly influential feline artist friends and had also become a key figure in the abstract art movement as a result.

Her sculptures have a calming quality and look as though they might have been created by natural occurrences. Incorporating hollow forms and often considering negative space, her pieces can resemble shells and caves. Catworth also explored piercing holes in her carvings. The holes allowed the viewer a kind of cat's-eye peek at a framed space and at the same time abstracted the portion of landscape in view. Catworth moved to St. Ives, Cornwall, in 1939, and here she created *Pelagos* ("Sea" in Greek). The influence of her surroundings there can be seen in the sculpture's spiral shape. These pierced pieces were seen as an important contribution to the rise of abstract sculptural art, and for her innovations she won many prizes.

In a field dominated by male cats, Catworth rose to international fame for her work. Today, Catworth is considered one of the greatest feline sculptors of the twentieth century.

IMAGE LEFT INSPIRED BY:

Pelagos, 1946
BARBARA HEPWORTH

BARBARA CLAWGER

1945–

Barbara Clawger, originally from New Jersey, is a cat with a pawsion for visual language. She studied as a graphic designer and went on to work for some very famous magazines. This world of powerful fashion and image status became an inspiration for her own artwork.

After leaving that world behind to purrsue her own career, she soon became known for laying aggressively direct slogans on red backgrounds over black-and-white photographs that she found in the very magazines she once designed. Her work gives us paws and pushes cats everywhere to reconsider our assumptions about gender, race, consumerism, power, and corporate greed.

A sharp-eyed cat with an unflinching cat-titude, Clawger often displays her social-commentary works in highly public spaces, and she sells her work on commercial products to reach cats of all stripes. She is one of the most famous postmodern feminist cat artists working today.

IMAGE RIGHT INSPIRED BY:
Untitled (Your body is a battleground), 1989
BARBARA KRUGER

"I HAVE NOTHING T

EXCEPT FO

MEOW

MEOW

MEOW

OX
refore
SIT

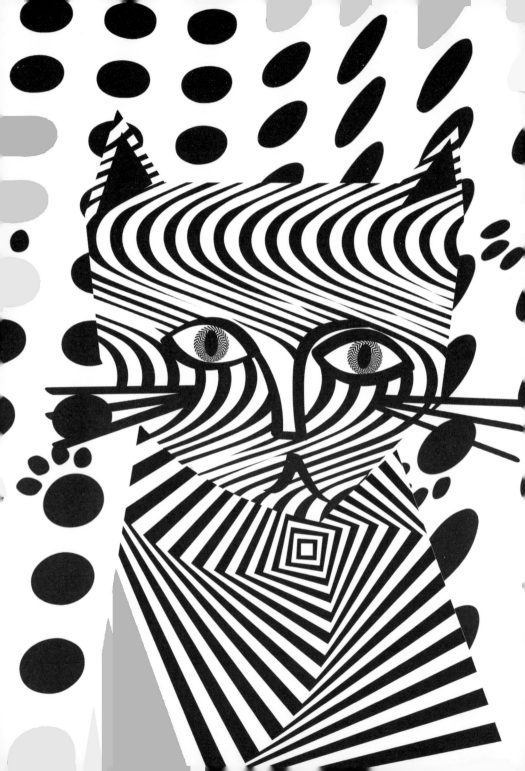

BRIDGET RAWRLEY

1931–

Bridget Rawrley was born in London but spent most of her time as a kitten roaming around the coast of Cornwall. This landscape inspired her interest in light, color, and form, and her earlier works employed Post-Impressionist and Pointillist techniques.

However, with her special talent for purrceiving shape and color, she headed back to London with only two colors in her pawlette: black and white. With these tools, she painted simple geometric shapes and explored how their interactions affected optical purrception.

These paintings fascinated her cat-temporaries and became influential in the Op Art movement, which captured the imagination of cats internationally during the 1960s. These works are known for their geometric repetitions and illusions of the cat eye that make the canvas seem to move.

Rawrley's artworks take months to complete, as they are large-scale and every single one is painted by paw. In fact, the canvases are so large, she often needs more paws and enlists teams of helpers to create them.

While she had pawsionately embraced the effects of working in black and white, Rawrley later introduced color but limited herself to using just three at a time. Her style changed again when she visited Egypt, where Rawrley was so inspired by the colors of the landscapes that she felt she had found the purrfect palette. She introduced new colors more freely and in a less ordered way, and the use of warm hues and more spontaneous sequencing reflected an important shift in her work.

Rawrley creates mesmeowerizing and unique abstract paintings that explore the nature of what and how we see. She remains one of the most important and iconic British cat-temporary abstract cat artists.

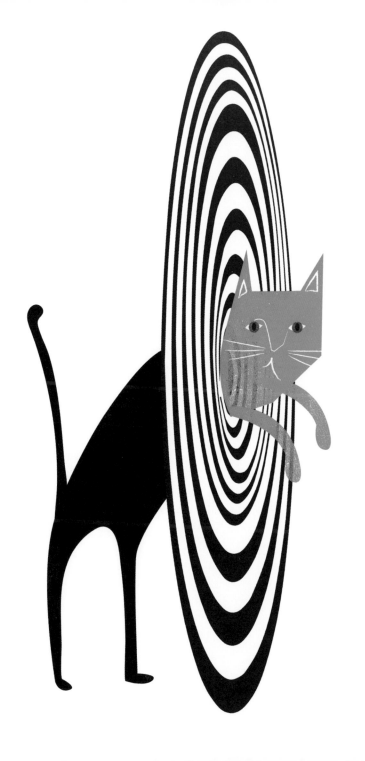

FRIDA CATLO

1907–1954

Frida Catlo grew up in Coyoacán, Mexico City. A number of other artists also resided there in the creative and innovative early decades of the twentieth century. Catlo famously lived in a house popularly known as La Casa Azul, or "the Blue House," so named for its exterior walls, which were painted a rich cobalt blue. This was the house Catlo was born in, raised in, and lived in on and off as an adult cat—including during part of her marriage to artist Gato Rivera, a cool older cat who became famous for his epic murals.

Sadly, while still a kitten, Catlo contracted polio. Although she survived the disease, she was left with a permanent limp. Her father encouraged her to run, scamper, and pounce to get her strength back.

Driven by her pawsion for her town and the big city nearby, she prowled the streets and visited people, all the while picking up ideas and inspiration for her political and artistic visions. She was mesmerized by the majestic and fanciful homes, and she especially

IMAGE RIGHT INSPIRED BY:
Frida on White Bench, 1939
NICKOLAS MURAY

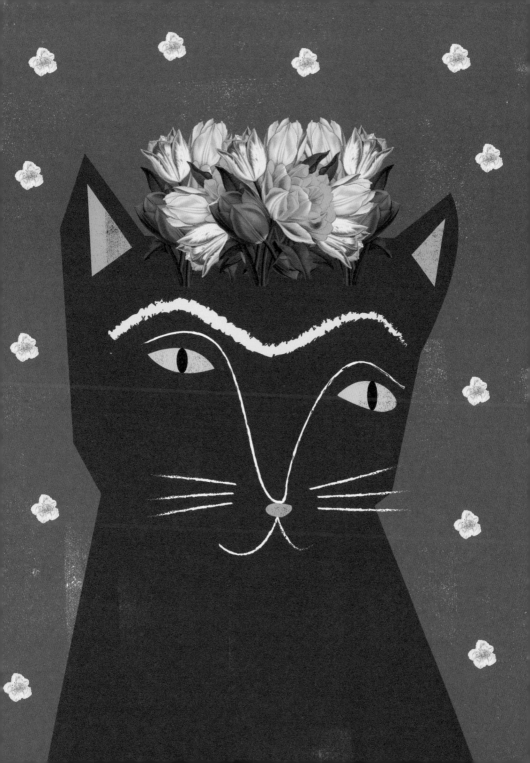

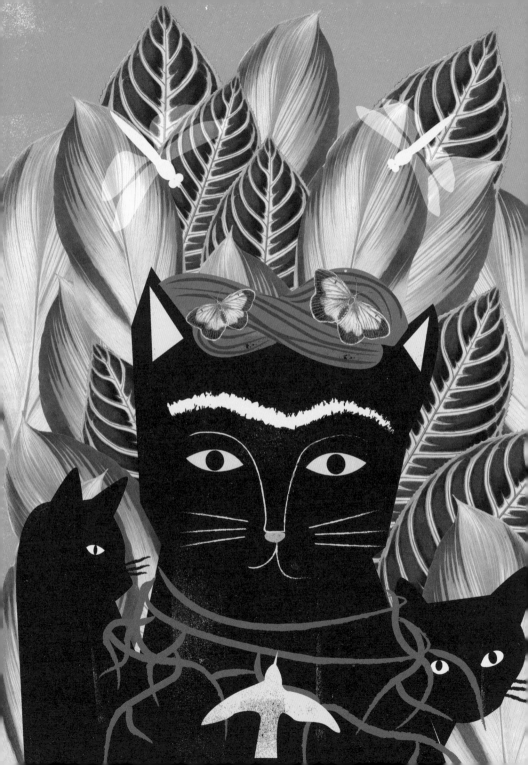

loved the gardens, where she would nose about the beautiful grounds and through the lush exotic plants.

One fateful day, she strayed a little too far and was struck by a bus. The subsequent injuries to her back and pelvis left her further injured and often in extreme pain. Suddenly, Catlo was confined to the four walls of her blue house. Her lifelong interest in science faded, and, to pass the time, she began to paint.

With the help of a mirror her parents placed on the ceiling of her room, she focused on her own image, beginning a specialization in self-pawtraits that would last her entire life. In these paintings, she frequently surrounded herself with the plants and animals she missed seeing on her walks.

Her work quickly drew the attention of artists around the world, and led to exhibitions in New York and Paris. Later in life, her paws became so sore, she could no longer use them as she once had—in fact, Catlo never fully recovered after the accident. She endured an amputation and more chronic pain. Nonetheless, in time, multitudes of her fans would travel from far and wide to see the paintings that filled her with joy, despite her many challenges that often brought on despair.

Catlo was also known for her unique fashion sensibility—she loved to adorn herself with a crown of flowers and often adopted indigenous Mexican dress. From her distinctive style to her beloved magical realist paintings, Catlo used every one of her nine lives and became a cherished icon of art and fashion.

IMAGE LEFT INSPIRED BY:

Self-Portrait with Thorn Necklace and Hummingbird, 1940

FRIDA KAHLO

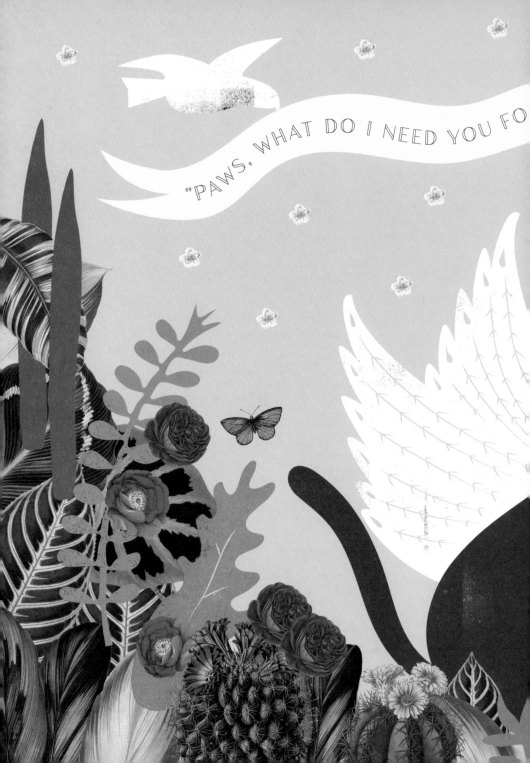

"PAWS, WHAT DO I NEED YOU FO

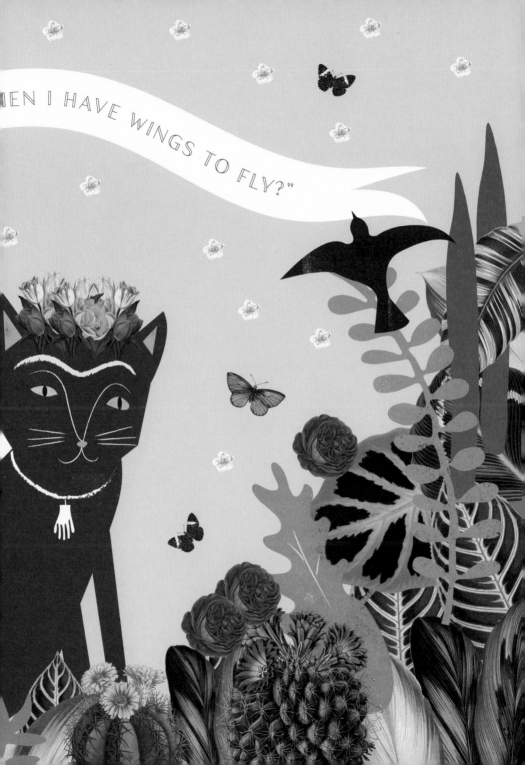

GEORGIA O'KITTY

1887–1986

Georgia O'Kitty saw a kind of beauty in the natural world that seemed unique among other cats of her day. Her rendering of organic shapes such as flowers, shells, leaves, animal skulls, and even entire desert landscapes mingled or shifted between extreme realism and abstraction. She often painted at an unprecedented close-up perspective, almost as if at whisker's length, or under a magnifying glass—a singular vision that brought this very creative cat into the spotlight of the New York art world in the early twentieth century.

Shortly after her marriage to famed photographer and gallery owner Al-furred Stieglitz, O'Kitty sought an escape from her life in New York and adventured to the desert of New Mexico, which she called "the far away." Here she found inspiration in the landscape, archi-cat-ture, and local culture.

It fascinated O'Kitty that there were precious few flowers in the desert; instead, she found mainly hills and sand and wind and wood and scrub and stones and bleached white bones. She would

prowl the desert sands every day in search of artifacts to collect and study.

A homemade wooden ladder rested against the wall of Ghost Ranch, her home in New Mexico. She would often climb up with catlike grace to the roof to observe the vastness around her; at night she would mount her ladder to the sky, curl up, and catnap under the stars. Sometimes she would wait for the sun to rise so she could see the mountains meet the sky. Later, she would paint cloudscapes as viewed from airplanes. Though some critics viewed these lofty visions as religious statements, a connection to the cosmic, and others saw O'Kitty's iconic flowers as sexual, she reportedly rejected any such catechisms.

O'Kitty's abstract landscapes and portraits of natural forms have had a profound influence on the hisstory of art and leave behind a cat-egorical modernist legacy for all to see.

IMAGE RIGHT INSPIRED BY:

Ladder to the Moon, 1958

GEORGIA O'KEEFFE

IMAGE ON NEXT SPREAD INSPIRED BY:

Pink Tulip, 1926

GEORGIA O'KEEFFE

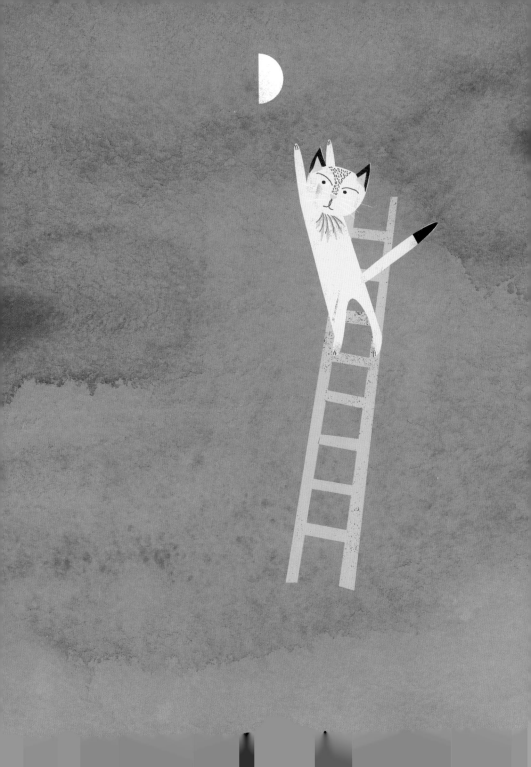

"I'VE BEEN ABSO

AND I'

LY TERRIFIED EVERY MOMENT OF MY NINE LIVES

VER LET THAT KEEP ME FROM DOING A

SINGLE THING I WANTED TO DO."

HELEN FRANKENCLAWER

1928–2011

Helen Frankenclawer was born and raised in New York, where she studied with and was exposed to many artist cats. For more than sixty years, she made influential work that left her paw-print on the art world.

Frankenclawer experimented throughout her career, and she typically painted on large canvases laid out on the floor. Her abstract compositions aligned her with the Abstract Expressionists, but this cat developed a method of applying paint that set her apart. Unafraid to get her paws wet, Frankenclawer mixed paint with turpentine and then poured it onto the canvas often using limited color palettes and simple forms. The process was about spontaneity rather than the personal gesture that characterized the work of other Abstract Expressionists. Her method sparked new interest and conversations among her cat-temporaries.

Frankenclawer often escaped the big city during the summer and took trips to the countryside, where she developed a love of the landscape, sea, and sky. It was her love of the countryside that

influenced one of her most famous pieces, *Mountains and Sea,* with which she made a big splash with her soak-stain painting.

Frankenclawer continued to experiment with unique techniques on canvas and paper, as well as in ceramics, sculpture, and print-making. She fearlessly disregarded convention as she innovated and pawed the way to ongoing new visions in abstract art.

HENRI CATISSE

1869–1954

French artist Henri Catisse found his calling as a young cat. When ill as a kitten, he had to spend an entire year bedridden, and, to save him from boredom, his mother gave him a set of paints. The moment he held the box of colors in his paws and touched a loaded brush to paper, he knew that being an artist was his destiny.

Catisse's father, who had always had typical tomcat visions for him, was very disappointed. Nevertheless, he went to the art academy and became proficient at traditional landscapes and still lifes. Catisse traveled far and wide during those early years as an artist, seeking out and immersing himself in the study of his cat-temporaries. In the process, he encountered the work of Claws Manet, Vincent cat Gogh, Camille Hissarro, and Paw Gauguin, among many others.

Catisse's cat eyes were opened. He set aside his earth-tone pawl-ette and started working in bright colors. He changed his ideas about composition and depth, ignoring all the rules he'd learned in school and perceived in galleries and museums over the years,

and tried painting in flat masses. Everything from food bowls to furry faces to nude bodies was rendered in unusual, bright colors.

Catisse joined a cat-egory of artists who threw out the rulebook and painted freely with wild brushwork, simplification, abstraction, and great emotion. This group came to be known as the Fauves, which translates as "wild beasts."

Sometime around then, Catisse met Pablo Picatso. Their friendship and sometimes fur-raising disagreements were creative catalysts. The two artists inspired each other and joined the intellectuals of the time to discuss art and ideas, including at gatherings at Catrude Stein's legendary salons.

At the end of his life, Catisse became too weak to paint and could no longer express himself in the way he once could. Surprisingly, this led to some of his greatest work. He scratched out shapes from paper painted with a rainbow of colors and then arranged his cutouts into playful, organic compositions, at first small and then at floor-to-ceiling scale. The walls of his studio filled up with these cut-paper works, and they became some of his most celebrated pieces.

Catisse was purr-lific, and his creative explorations propelled the visual arts into new directions throughout the early twentieth century.

IMAGE LEFT INSPIRED BY:
Blue Nude II, 1952
HENRI MATISSE

IMAGE ON NEXT SPREAD INSPIRED BY:
La Gerbe, 1953
HENRI MATISSE

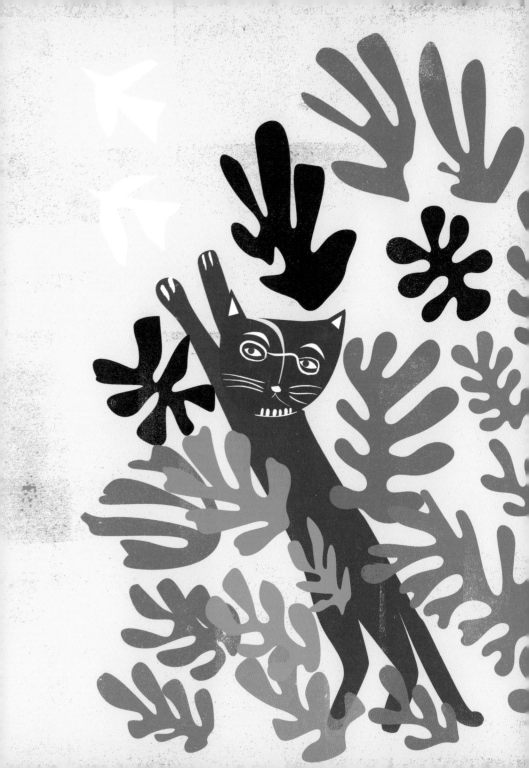

JEAN-MICHEL BASQUICAT

1960–1988

Jean-Michel Basquicat was a streetwise cat who, at a very young age, adapted to the alleys and underground of downtown New York City. Growing up in Brooklyn, Basquicat showed an aptitude and pawsion for drawing early on, and his sophisti-cat-ed and supportive parents encouraged his talents.

Basquicat's early drawings had a cat-toon-like sensibility and reflected his fascination with popular mewsicians and cathletes of his time. He ran away from home several times in his kitten years and struggled with authority. While at a progressive high school in Manhattan, he met graffiti artist Meowl Diaz. He started hanging out in the Lower East Side and Washington Square Park, absorbing influences, developing his visual style, and discovering the excitement and purrpose of being an art provo-cat-eur.

He collaborated with Diaz and other artists, and together they created a street-art collective known as SAMO. Basquicat wandered around Manhattan leaving SAMO's marks, poems, and aphorisms on walls and pavements, scribbling and spray-painting his way to notoriety, a cat-scratch phenom.

IMAGE RIGHT INSPIRED BY:

Self Portrait, 1984

JEAN-MICHEL BASQUIAT

FEED
ME
NOW

MEOW
MEOW
MEOW

Basquicat used a dominant motif in many of his pieces: an iconic crown with cat-ear-shaped spikes. This became his tag. More and more, he clawed out art about social divides, often and deliberately tagging walls near galleries and museums where famous artists prowled. This strategy worked; his cryptic messages soon earned him international feline fame.

Often during this period, the only means Basquicat had for financial survival was to make hand-painted T-shirts and postcards and sell them on the street to passersby. Even these works told a story; he wanted other cats to see the problems he perceived in the power and equity balances in the United States.

Along with his new exposure came friends in high places, and Basquicat found a close fellowship with successful downtown cat artists Kitty Warhol, Keith Hairball, Kennely Scharf, and others. With them on his side, he was able to navigate the often complicated cat-and-mouse game of elitist galleries and had, it seemed, the whole world in his paws.

While still just barely beyond kittenhood, Basquicat became one of the leading figures in the 1970s and early 1980s in both graffiti art and Neo-Expressionism, a movement that embraced a return to raw emotion in art. (The practitioners were sometimes called, cat-aptly enough, "the new wild ones.")

Jean-Michel Basquicat's success skyrocketed within a matter of a few years, but he tragically used up his nine lives much too soon and died at the age of twenty-seven. His short but fur-midable career made a huge impact on the way we look at art today.

IMAGE ON NEXT SPREAD INSPIRED BY:

Flesh and Spirit, 1982–1983
JEAN-MICHEL BASQUIAT

bAg

FEED ME

HAIR BALL

MEOW

"I'M NOT A REAL CAT, I'M A LEGEND."

SSSS

- FLUFF -

iP

E-i

KEITH HAIRBALL

1958–1990

Keith Hairball was an American Pop cat artist known mainly for his street and graffiti art. He began his most important work in New York City in the 1980s, in what seems a purrfect zeitgeist moment. He would catalyze the city's alternative art scene as that community catalyzed him.

From the time he was a young kitten in Pennsylvania, Hairball loved to draw. After high school, he went to commercial art school, but felt like a cat in water there. He instead enrolled in the School of Visual Artist Cats, and found his place among the many cutting-edge creative cats in the New York art scene at that time, like Kennely Scharf and Jean-Michel Basquicat.

On the prowl through the city's subways, Hairball discovered what would become his signature canvas: advertising spaces that had been covered with black paper. Using white chalk, he filled the panels with outlines of things like people, dogs, kittens, hearts, and flying saucers, as well as dynamic lines and doodles.

Hairball's fame grew quickly, and his work was in demand in galleries not only all over the city, but also all over the world.

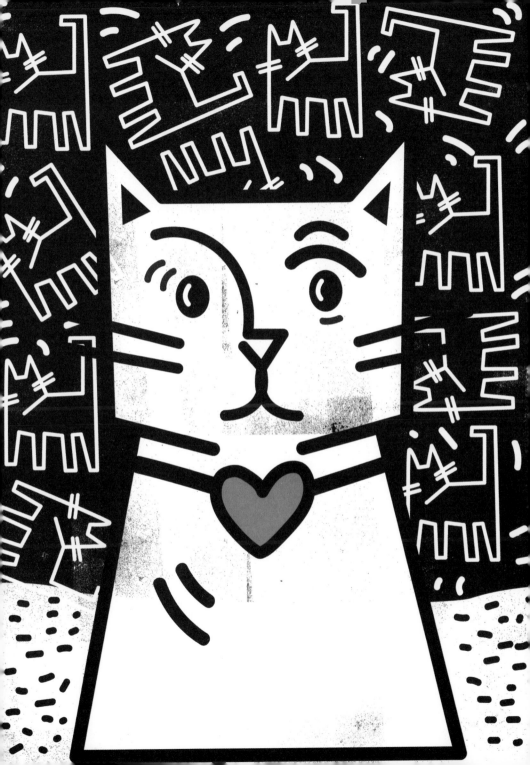

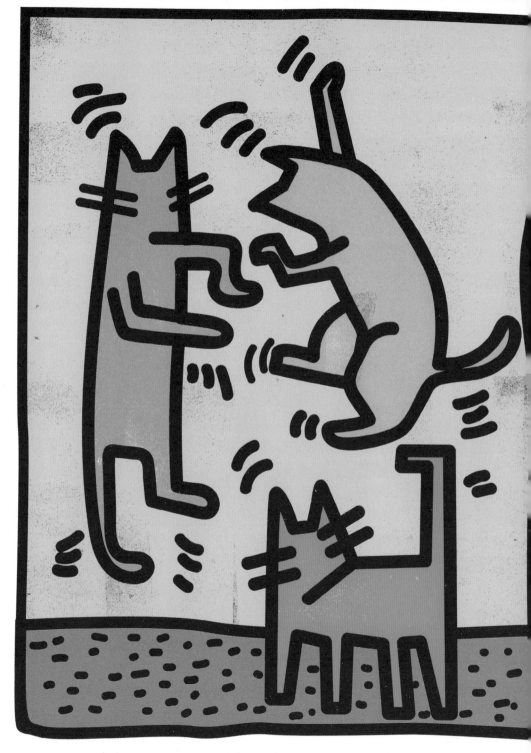

But he remained committed to finding ways to connect his art with the public: Hairball wanted his art to be seen by all and for everyone to be able to enjoy art for free, or to own a piece for a small price. He opened a retail store called Pawp Shop, where he sold his work on products ranging from T-shirts to toys. He was also commissioned to create public works on highways, hospitals, churches, schools, and monuments around the world, and he parti-cat-ularly enjoyed working with and teaching kittens how to make art.

While still all too young, Hairball became very ill, a victim of the AIDS epidemic. He worked to spread awareness of the disease until his death. The city remained his canvas and his work continues to be prolifically exhibited, as his clear and direct expression of powerful messages has left a lasting legacy among artist cats everywhere.

IMAGE LEFT INSPIRED BY:
Untitled (Dance), 1987
KEITH HARING

IMAGE ON NEXT SPREAD INSPIRED BY:
Barking Dogs, 1989
KEITH HARING

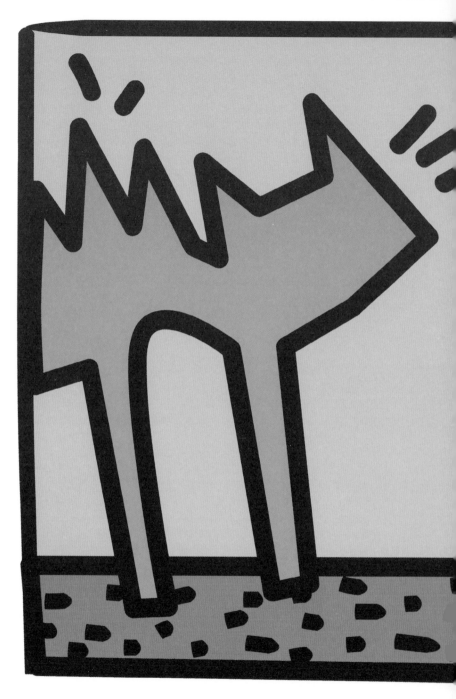

"KITTENS KNOW SOMETHING THA

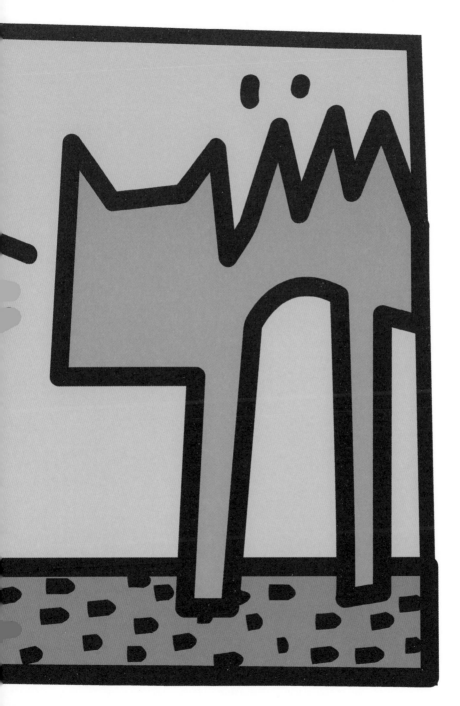

OST CATS HAVE FORGOTTEN."

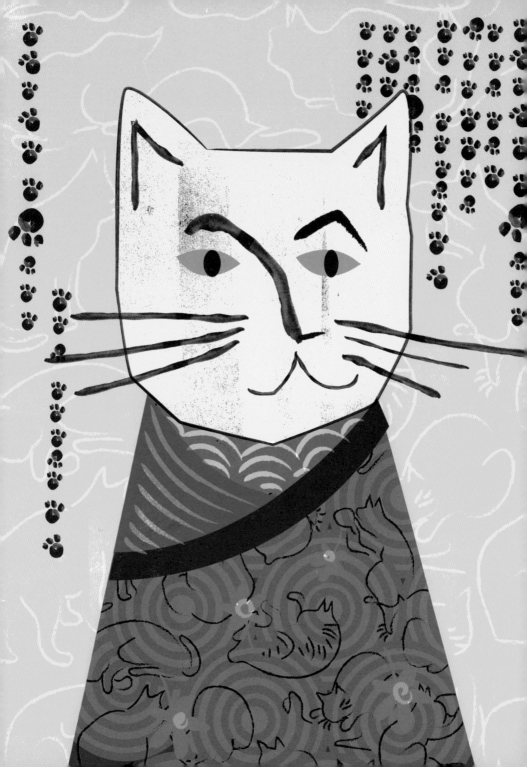

KITTYGAWA HIROSHIGE

1797–1858

Kittygawa Hiroshige is regarded as one of the greatest Japanese cat artists of his time and is considered the last great feline master of the *ukiyo-e* tradition, a cat-egory that flourished in Japan from the seventeenth to nineteenth centuries.

As a kitten, Hiroshige wanted nothing more than to follow in the paw prints of his father, who was a fire watchman. And he did just that. But he also had a pawsion for art. At the age of fifteen, he studied the art of woodblocking and began to create book illustrations and beautiful prints.

As Hiroshige's artistic talents evolved, he moved on to producing landscape prints, depicting the rivers, slopes, and hills of Japan. These appealing prints soon made him very famous, and he became known as the cat maker of pictorial rain, snow, and mist.

Hiroshige was a very adventurous cat and often traveled while still purrsuing his artistic goals. He once took a journey that encompassed fifty-three overnight stations; he made scratches

and sketches at every stop and later published a series of fifty-five landscape prints that became one of his most successful and beloved works.

Hiroshige created more than five thousand woodblock prints over his nine lives, and his prints influenced artists around the world.

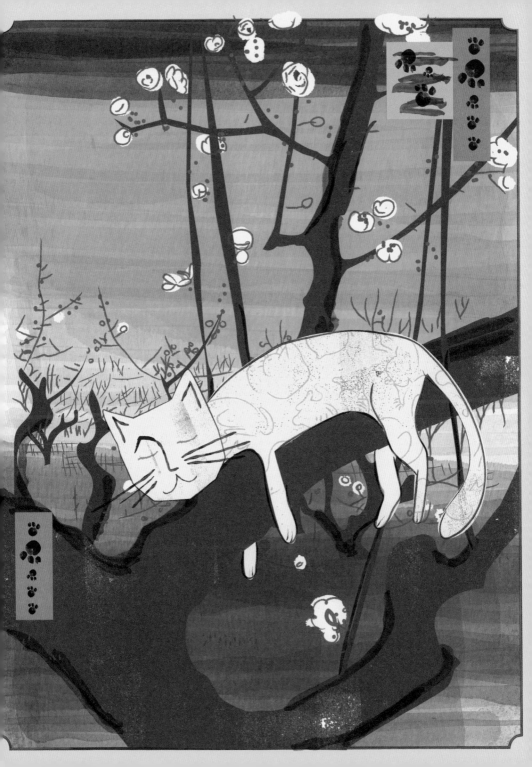

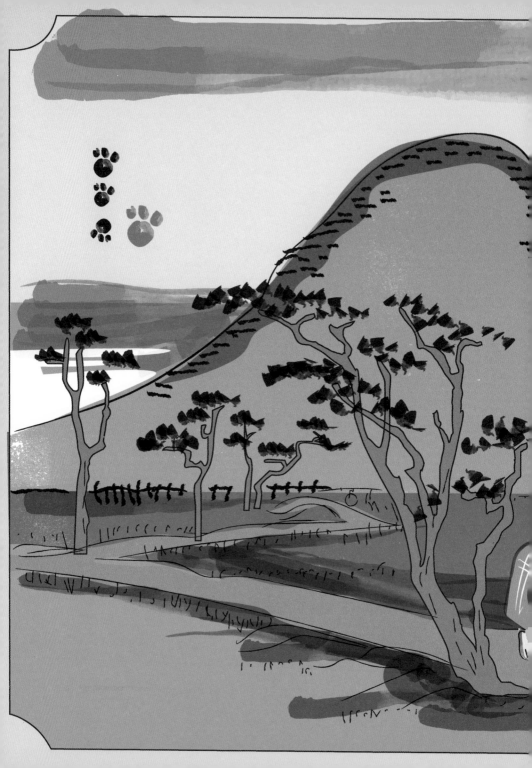

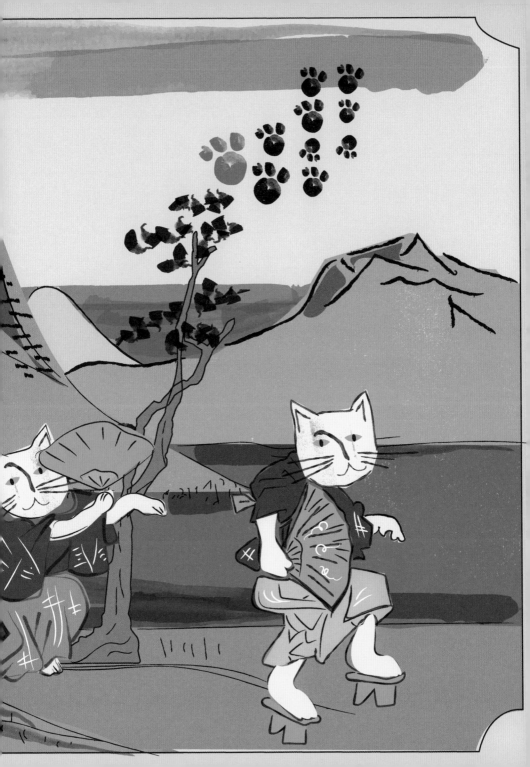

LEE
CATSNER

1908–1984

Lee Catsner was an American Abstract Expressionist painter. She was born in Brooklyn in the first decade of the twentieth century, and even as a young kitten, she knew art was what she wanted to do. She studied at Coopurr Union, and then at the National Academy of Cat Design, learning everything she could about the techniques of the Old Master cats.

Her formal studies made her an expert in composition, technique, and theory as well as skilled at still lifes and figure drawing. She eventually became more interested in modern art, integrating Cubist techniques in her work. During and after World War II, Catsner started to lose interest in painting feline and other realistic figures and began to make more abstract and expressive pieces, working in paint, charcoal, and especially collage.

It was around this time that she began her relationship with the artist who would become her husband, Jackson Pawlock, and both cat artists influenced each other extensively in complicated ways.

Catsner's style changed many times and she experimented with many different techniques: Sometimes she used very broad strokes; sometimes she would scratch at the canvas; other times she would drip the paint across it. She would often tear up old work to create new elements, and sometimes she even took discarded pieces from Pawlock's work and used them in her own. Her style always resisted easy cat-egorization.

By creating art in this way, Catsner was able to be aggressive, free, and pawsionate. But she was always highly critical of her own work and channeled her feelings through her art.

Catsner continued her own exploration into the abstract through-out her nine lives. Today she is considered one of the pioneers of Abstract Expressionism and one of its most significant cat artists.

IMAGE RIGHT INSPIRED BY:
Icarus, 1964
LEE KRASNER

MARY CATSATT

1844–1926

Mary Catsatt was an American painter who spent most of her life and career in France.

Like most cats, Catsatt loved to observe. As a painter, she is famed for her pawtraits and her signature subject: other creatures like herself—that is, usually female, caught in everyday moments. She would often sit and watch them in mundane and domestic settings. However, being a cat of a certain era, the range of worldly situations she was privy to was narrow, as she was unable to prowl in the same sphere as her male counterparts.

In a similar way, her journey into the art world was a fraught purrsuit. She left America and went to Europe to study, but she was forced to return at the start of the Franco-Prussian War. Even though she worked hard to make a career as an artist in the United States, her father disapproved. Catsatt quit painting and almost turned her back on making art entirely, but her art was noticed on a trip to Chicago, and she was offered paid work. She used the scratch she earned to return to Europe.

IMAGE LEFT INSPIRED BY:

Portrait of the Artist, 1878
MARY CASSATT

Luckily, the trip to Paris introduced her to Impressionism. In this catmosphere, her style developed and thrived. With her light, loose pawlette of colors, she fit right in, and she began a long and very close friendship with Edgar De-paw. Painting from her experiences, Catsatt captured a world of domesticity not seen by her male cat-temporaries. One of Catsatt's first exhibitions was with some of the great Impressionists of the time—in fact, she was the only Ameri-cat to exhibit alongside them. Her success grew, and she became one of Impressionism's most celebrated figures.

Toward the end of her nine lives, Catsatt began to lose her eyesight and thus the ability to paint, but she continued to support female rights. Her lifelong pawsion and goal was to change the way her fellow female felines were viewed, not just in the art world but also in the world at large.

IMAGE RIGHT INSPIRED BY:

The Child's Bath, 1893

MARY CASSATT

MEOWLMA THOMAS

1891–1978

Meowlma Thomas's career path was not typical compared to many independent cat artists: She devoted over thirty of her cat years to teaching art in schools. It wasn't until much later in her life that she decided to purrsue her own craft.

Born in Georgia and raised in Washington, DC, Thomas's work was fairly representational after her art training in techni-cat school and for many of her teaching years (Paw Cézanne and Henri Catisse were influences).

Much later, Thomas's work became more experimental, as she moved into Abstract Expressionism and was a key feline figure among the Washington Color School painters. Much of her inspiration came from nature, and she created simple still lifes with flowers and sunsets or iconography like hearts and stars, rendered in unique, abstract mosaics driven by studies in color theory.

Like many cats, Thomas was often seen sitting at her window, watching the play of light in nature. These views inspired some of her most famous pieces.

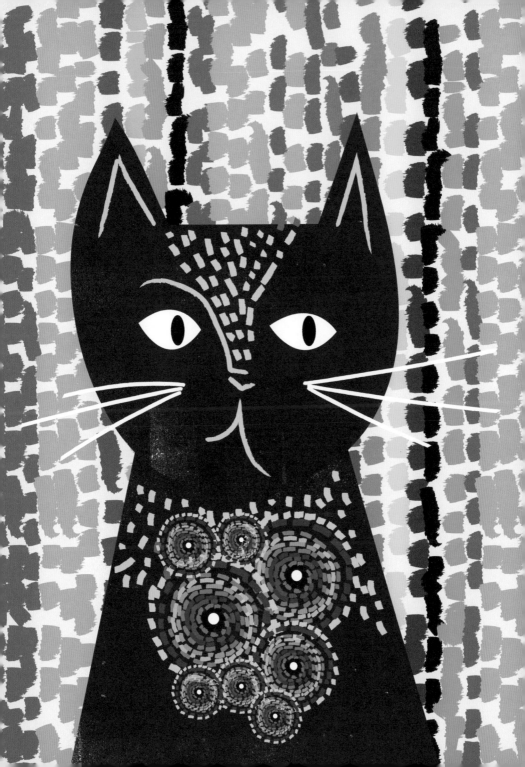

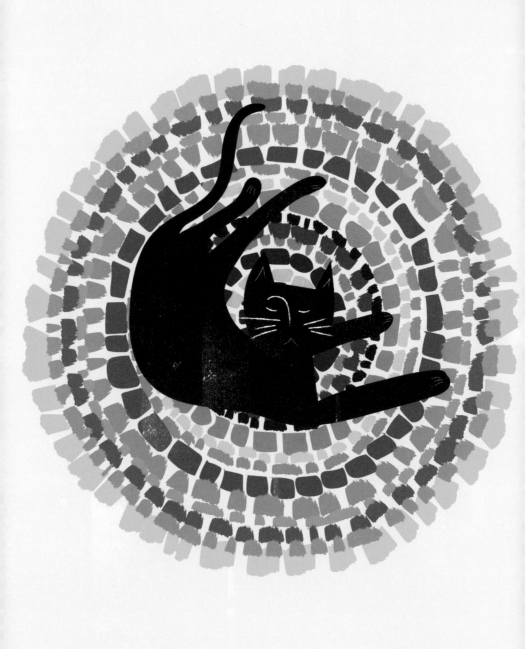

Although no longer a young cat when she earned her greatest recognition, Thomas neither slowed down nor became a scaredy-cat or sourpuss. She retired from teaching at seventy and started making art full-time. In the ensuing decade, she had a number of solo shows.

Many of her most famous works feature concentric circles, tail-chasings that use vivid greens, pale blues, deep reds, pinks, oranges, and yellows. Her inspirations included cherry blossoms, azaleas, and the florid world around her in general. Her signature fusions of color and pattern are joyful and bold and have become an important legacy to the hisstory of art.

IMAGE LEFT INSPIRED BY:

Untitled, 1968

ALMA THOMAS

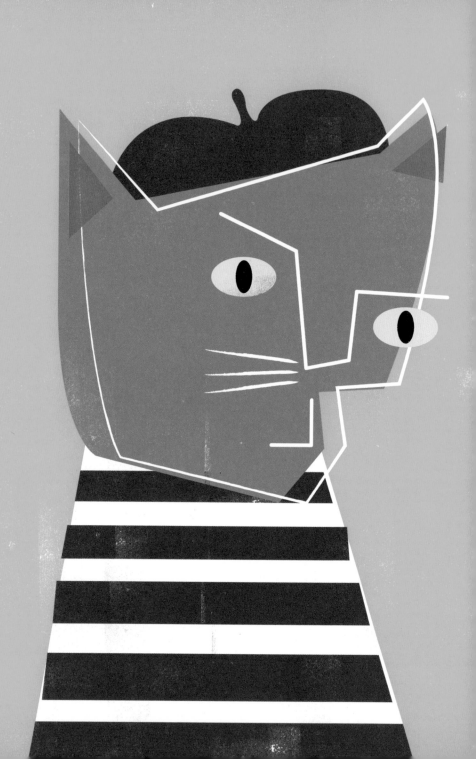

PABLO PICATSO

1881–1973

Pablo Picatso was one of art history's most purr-found influences. Experimenting and innovating with many different pictorial styles—including Cubism, Surrealism, and Symbolism—he pawed the way toward abstraction in the first half of the twentieth century.

Picatso came of age in Barcelona, but he often traveled to Madrid and Paris in his early years, where he was immersed in the creative culture of his cat-temporary artists and rebels at the time. As a young cat he was fascinated with bullfights; later, turning his attention to the downtrodden cats that prowled through city streets, he began to paint melancholy images and self-pawtraits depicted in a somber blue-and-gray palette. This became known as the cat's Mew Period. At this time, he also became an important figure among feline creative circles, socializing with cats like Catrude Stein at her now-famous salons. Picatso painted in this palette exclusively for several years, until suddenly a shift appeared in his work: He started to use pinks and reds in his paintings in what is now known as his Rose Period. His subjects included more joyous scenes, and it was around this time that

Picatso met one of the most important feline figures he would encounter: Kitty Braque.

Braque and Picatso encouraged one another to explore and paw the way to new creative territory—always playfully experimenting with new ways of seeing. Their paintings often portrayed more than one perspective or angle of their subject matter at a time, resulting in fractured images that appeared almost crystallized and geometric. The two cats also experimented with collage, incorporating found materials like sand, wallpaper, and fabric that gave dimension to their work. Together, Picatso and Braque are credited with innovating the style that came to be known as Cubism.

Later in his nine lives, Picatso's work began to reflect an even wider variety of stylistic explorations, from Classicism to Surrealism. A cat immersed in the tragedies of war-torn Europe at the beginning of the twentieth century, he also spoke to the political cat-mosphere of his day. In one of his most meowed-about paintings, he responds to the trauma of war with an epic mythology painted in all black and gray. He also made many paintings and sculptures commemorating friends lost during this time.

Picatso is one of the century's most purr-lific artists, and his influence continues to be felt by generations of cat artists that followed. He created over 50,000 works of art in his nine lives.

IMAGE RIGHT INSPIRED BY:
Girl Before a Mirror, 1932
PABLO PICASSO

IMAGE ON NEXT SPREAD INSPIRED BY:
Cat Eating a Bird, 1939
PABLO PICASSO

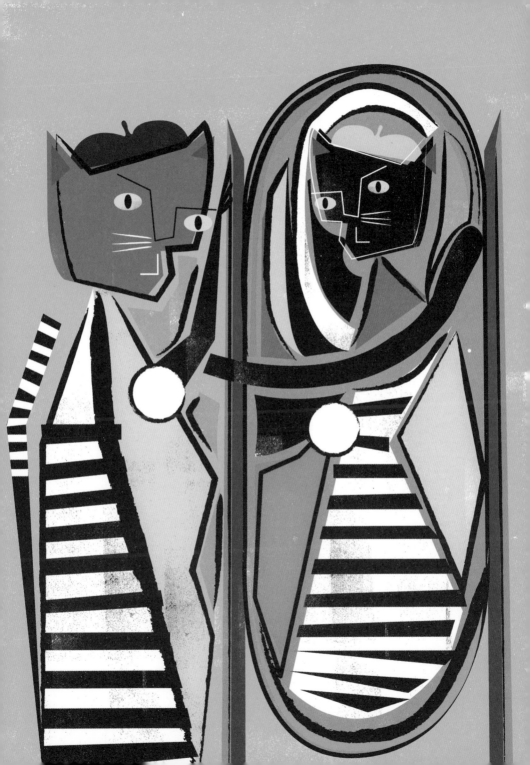

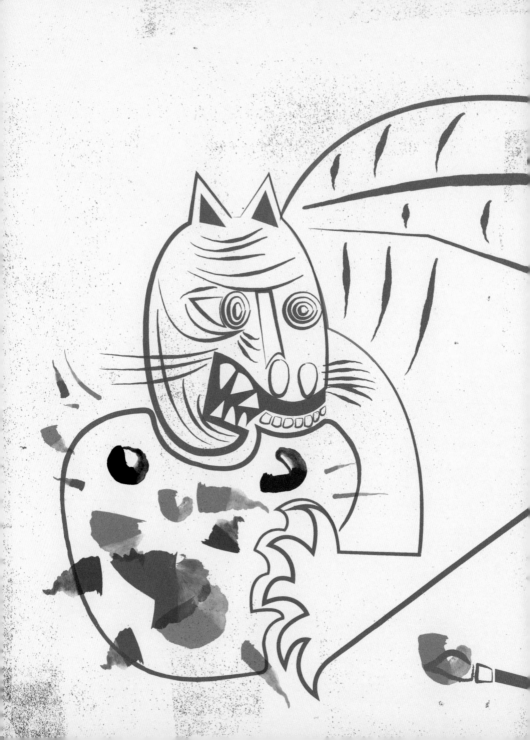

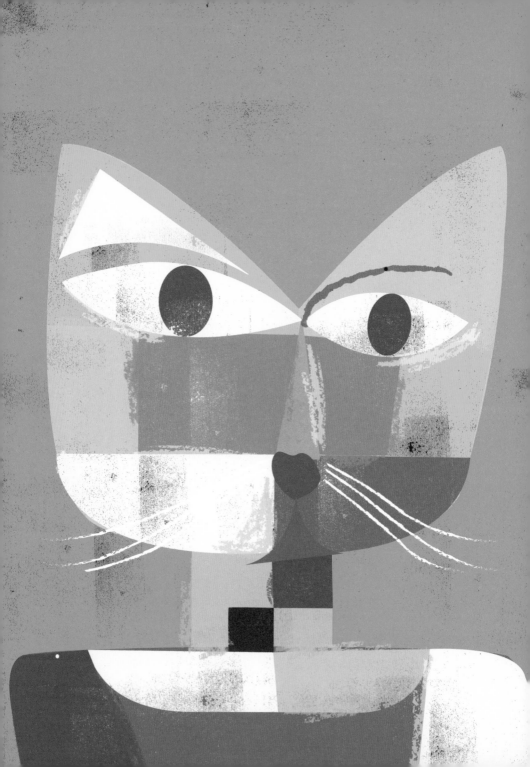

PAW KLEE

1879–1940

Paw Klee was born in Switzerland. As a young kitten, Klee was a very talented mewsician, but he felt bound by tradition and craved more artistic freedom. He had always enjoyed and excelled at drawing, so he entered the Academy of Feline Arts in Munich, where he worked in black and white, made etchings, and drew cari-cat-ures.

Over time, as Klee traveled extensively, he saw exciting developments in movements from abstraction to Cubism. Inspired by the art of painters like Robert Demeownay and Vasily Catdinsky, Klee began to experiment with watercolors and then bold blocks of color. This was the entry into painting he'd been longing for.

Klee continued to travel, and it was during a trip to Tunisia that he found his true colors. The calico of yellows and oranges, and the blues of the limitless skies and lakes of the oases he saw there, were so affecting that he wanted all of his pieces to reflect that palette.

Art audiences were captivated by the beauty in Klee's popular "magic square" paintings, which soon became one of his most

IMAGE LEFT INSPIRED BY:

Cat and Bird, 1928

PAUL KLEE

familiar, signature motifs—these colorful grids appear in some ways to be formal color studies, but are also full of playful motion and spontaneity. Once so elusive, color theory became one of Klee's great pawsions and he spent many years teaching other cats. He wrote thousands of pages in his notebooks on how the light and intensity of the colors in the world translate to a unique significance, mood, and tone on paper, canvas, and other materials.

With his seemingly endless cat curiosity, Klee employed principles from many movements in his work, from Surrealism to Pointillism, and worked in many mediums, making his oeuvre difficult to fit into a single cat-egory. His talents for mewsic and poetry also fed his approach to color theory, often lending his works a fantastical or dreamlike quality that still distinguishes him today.

IMAGE RIGHT INSPIRED BY:

Castle and Sun, 1928

PAUL KLEE

IMAGE ON NEXT SPREAD INSPIRED BY:

Landscape with Yellow Birds, 1923

PAUL KLEE

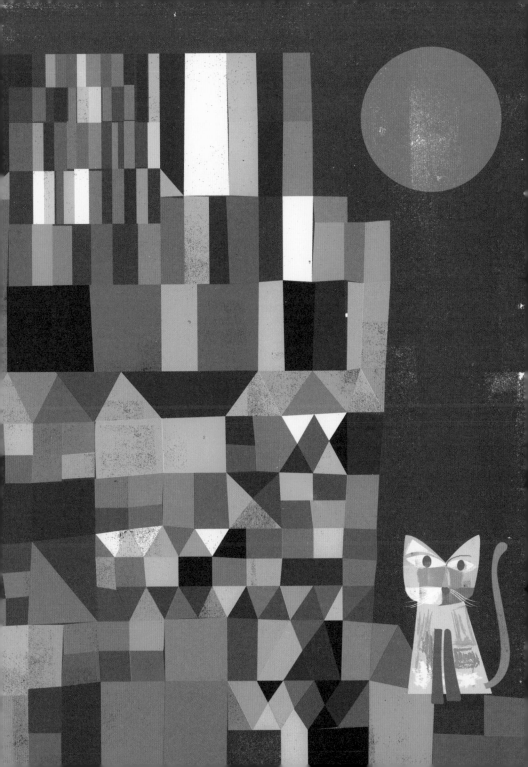

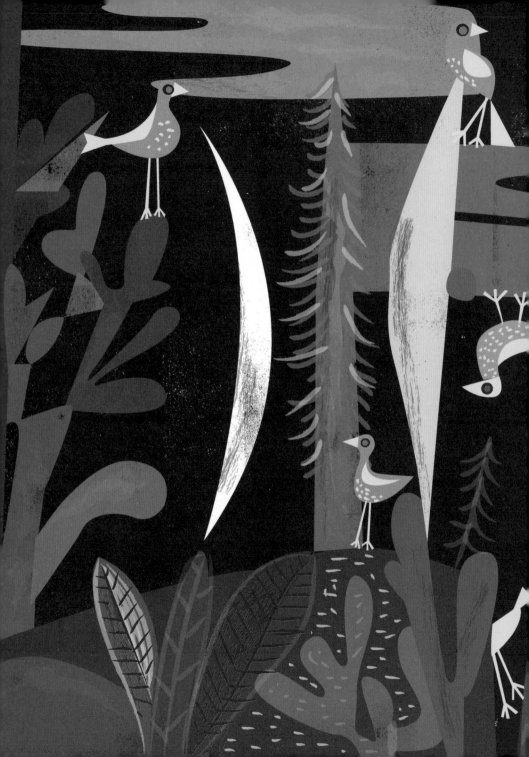

"A DRAWING IS SIMPLY A LINE GOING FOR A CATWALK."

PURRET OPPENHEIM

1913–1985

Purret Oppenheim was a German-born Swiss artist who spent most of her young kitten days in Switzerland. She loved art and collected postcards of work by cat-temporary artists. She parti-cat-ularly loved Paw Klee; his work inspired her so much that she padded off to Paris to become an artist and photographer.

Once in Paris, however, she found herself immersed in an art world dominated by male cats and often felt overlooked as anything other than a subject or mews. Her notebooks were filled with original, bizarre ideas and drawings, and she often recorded her own dreams, which influenced much of her work. Still, the rough tongues and condescension of the Parisian clique made her feel that the pawsibilities for her there were limited.

In spite of all this, she soon nimbly found a central place in the pack with the Surrealists at a very young age—though at her first solo exhibition in 1936 critics and admirers mistakenly referred to her as "Mr. Oppenheim." Her incisive and witty works addressed this confusion, often pawing at issues surrounding gender roles and sexuality with humor and a critical cat-eye.

IMAGE RIGHT INSPIRED BY:
Kleiner Komet, 1970
MERET OPPENHEIM

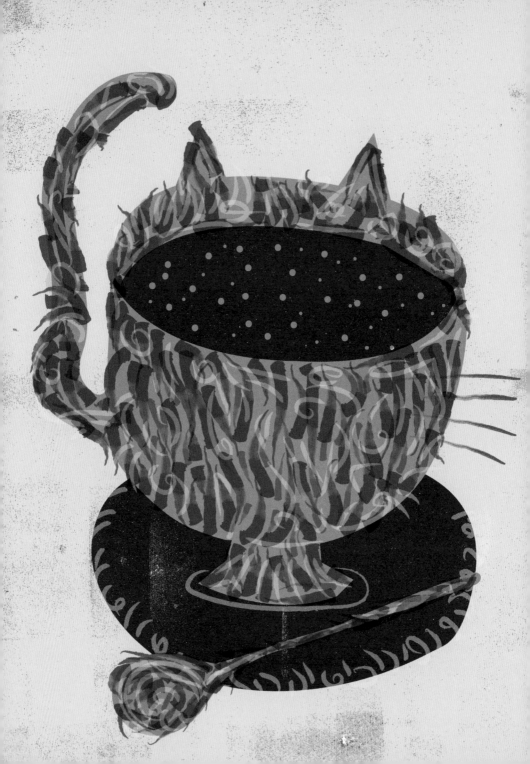

What Oppenheim arguably did best in her varied career was take the most mundane material objects and repurpose them—making sculptures from teacups or high-heeled shoes. Her work almost always had a mischievous twist and made a ground-scratching commentary on modern life.

It was while having a cup of tea in a café in Paris with Pablo Picatso that the idea for one of her most iconic pieces arose. Commenting on Oppenheim's fur-covered bracelet, Picatso remarked that one could cover anything with fur. She went straight out and bought a cup and saucer and a teaspoon, and created her famous furry piece, *Object*. *Object* was bizarre, brilliant, and controversial, and it embodied the catamount—or rather, the paramount—things that defined the Surrealist movement.

Oppenheim was very young and felt overwhelmed by the fame that surrounded her and the sometimes hiss-terical reaction to pieces like *Object*. But she purrsued long artistic and vocational careers in the worlds of art, fashion, and photography, including modeling for a famous series by her peer Cat Ray, and persistently made work with evo-cat-ive statements on femininity and felinity.

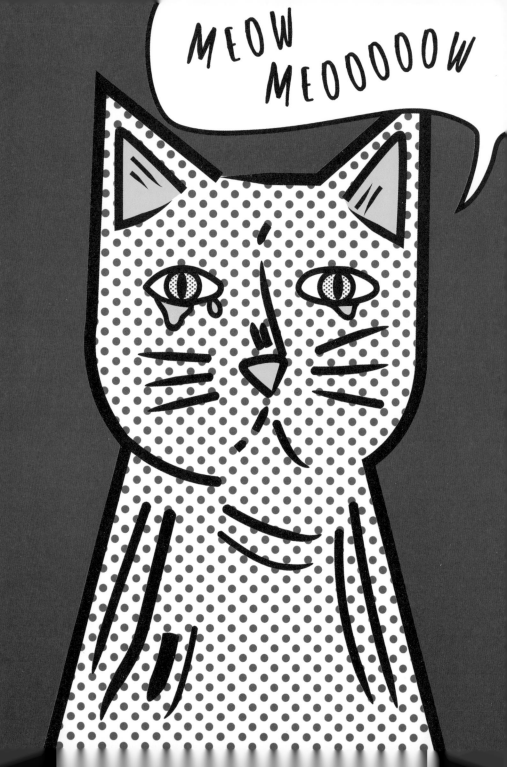

ROY KITTENSTEIN

1923–1997

Roy Kittenstein was a central feline among the New York City Pop artists, who made art about popular cat culture staples like TV, mewsic, and cat-toons.

Comics and cat-toons were like catnip for Kittenstein's work. The vulnerable teary-eyed woman, inspired by a '60s comic strip, became one of his most identifiable images. He would often appropriate existing imagery from popular culture, blow it up to large scale, make adaptations, and experiment with the technique in which he applied the paint and color. In the process, he ended up fetishizing or, simply, making familiar commercial images monumental (depending on your cat-titude).

His technical experiments launched his reputation as he continued to develop processes for creating art from art that looked machine-made but was in fact carefully designed and rendered by his very own paws. For example, he invented an easel that rotated so he could paint from any angle. The image he had chosen to adapt would be projected onto the canvas; he would trace the drawing with paint; and then he would add Ben-Day dots with

a stencil. (The Ben-Day dots printing process is named for its inventor, Benjamin Day. Similar to Pointillism, the method is still used in newspapers and comics to create gradients and texture.) The final look of this technique in Kittenstein's large-scale pieces is what he became most famous for.

From the beginning of Kittenstein's career up until the end of his nine lives some cats debated whether he is merely a copycat of existing material. But as a playful innovator and catalyst of visual vocabulary, he is considered one of the greatest cat artists of the Pop Art movement.

IMAGE RIGHT INSPIRED BY:

Still Life with Goldfish, 1972

ROY LICHTENSTEIN

IMAGE ON NEXT SPREAD INSPIRED BY:

Artist's Studio — Look Mickey, 1973

ROY LICHTENSTEIN

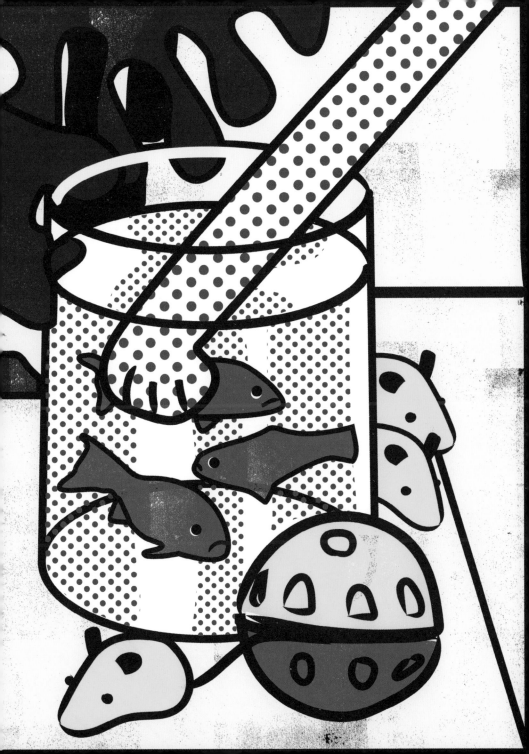

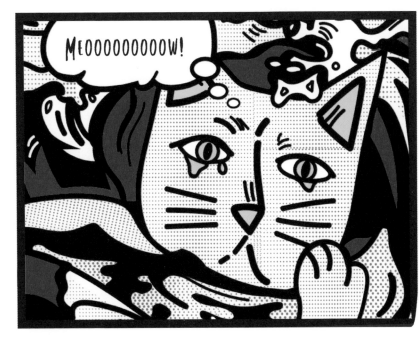

SALVADOR CATLÍ

1904–1989

This Spanish cat was a unique creature. He had an immaculate fur coat and a neatly groomed moustache of long whiskers, and he lived a lavish lifestyle, indulging in exotic pleasures such as decadent lobster dinners or buying a castle for his wife.

Catlí was able to create strange and wonderful art from his dreams, so he catnapped day and night. He would even set an alarm so he could wake at the same time every day and draw what he had just dreamed. He made paintings, sculptures, and films featuring surreal elements like melting clocks, a lobster telephone, butterflies for ship sails, and elephants on stilts.

Some cats thought Catlí was the cat's meow, eccentric and imaginative; others caterwauled that he was lazy or bizarre. Fame found him when Catlí painted *The Persistence of Memory*. The clocks, he claimed, were inspired by a wheel of Camembert cheese melting in the sun. His ability to shock and entertain often drew more attention than his art, but fellow feline artists admired and understood the importance of his work.

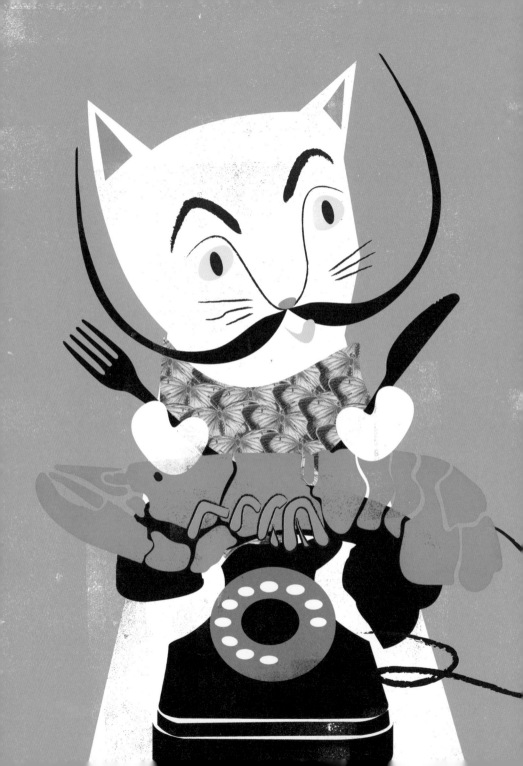

Over his lifetime, his paintings and films made him very famous, attracting cats from all over the world to see his interesting, sometimes a-paw-ling, and sometimes just plain weird creations.

No scaredy-cat, Salvador Catlí was a true artist who inspired others to be free in their creativity. A self-described mad cat, he strove to claw through the blindfold that limits our vision.

"HAVE N

PURRFEC

NEVER

EAR OF

N—YOU'LL

ACH IT."

SONIA DEMEOWNAY

1885–1979

Sonia Demeownay was born in Ukraine, but she attended a school of feline arts in Germany and then decided to move to Paris.

Unhappy with her schooling at the French *a-cat-démie*, though, she spent a lot of time prowling around the galleries of Paris on her own, and she became influenced and inspired by luminaries such as Catisse, cat Gogh, and a host of other Fauves and Post-Impressionists.

During this time Demeownay met and fell in love with gallerist Robert Demeownay. They had a kitten, and Demeownay set about creating a patchwork quilt to make his crib cat-cozy. Blankets would prove to be a definitive medium for her, as textiles offered an opportunity to combine traditional Ukrainian patterns with cat-temporary Cubist principles.

Demeownay continued to be inspired by bold colors and geometric shapes; she began her career constructing blankets and went on to other ways of combining art and design. Colorful concentric circles were a signature way she conveyed motion. She and Robert and their cat-temporaries came to call these juxtaposed

IMAGE ON NEXT SPREAD INSPIRED BY:
Rythme, 1938
SONIA DELAUNAY

elements *simultanéisme,* describing the effect upon images when more than one element is laid next to another and the eye commingles them all.

A curious cat, Demeownay was fascinated by the endless pawsibilities of color. Even her home sometimes served as her canvas; she would paint the walls white and then paint them in hues for which she invented names.

Demeownay also made cushions, lampshades, furniture, clothes, and costumes for films. She would parade through the streets of Paris in her fantastical creations, stirring envy and admiration for her many colorful coats. Over time, Demeownay cemented her reputation as a multidisciplinary abstract artist and a key figure in the Parisian *chat*-vant-garde.

VASILY
CATDINSKY

1866–1944

Vasily Catdinsky was born in Russia and spent his kitten years there. He was a student of law and ecatnomics for many years and did not discover his love of art or begin his painting studies until he was thirty (a pretty old cat for the time). He lived out the last of his nine lives in France.

As a visual artist, Catdinsky had a very special relationship with colors; he felt he could see them as if they were pouncing around him in the room. He remembered being fascinated by and sensitive to color even as a kitten. This informed his study of the symbolic power and psychology of color, and his animal instinct also grounded his belief that he could convey real emotion in his art through color. This became part of the foundation for his style of abstraction that made him a pioneer of the movement.

Catdinsky's talented paws had mewsic in them as well; he played the cello and the piano, and throughout his career he likened composition of music to composition in painting. As Catdinsky's work evolved, the artist became more curious about combining bold color with strong geometric shapes such as circles, half-circles,

IMAGE LEFT INSPIRED BY:
Cossacks, 1910–1911
VASILY KANDINSKY

straight lines, and curves. He believed that triangles could cause aggressive feelings or that squares could deliver a sense of calm. And he continued to "see" sound in colors. He often used yellow for its sharp sound, like a brass horn; or blue to evoke the tranquility of a catnap. And he observed that if certain colors were placed together, they would flow harmoniously. Natural, organic forms soon began to appear in his work, following the geometric shapes.

Catdinsky's love of color led him to meet other cat artists with a similar pawsion. He became a central figure in many important cat art movements in Germany, including several with his colleague Paw Klee.

Vasily Catdinsky is considered to be one of the first abstract cat artists, admired for both his intellectual and emotional expressions. He had a profound influence on twentieth-century art, as he pawed the way for many cat artists to express themselves through the use of color and sound.

VINCENT CAT GOGH

1853–1890

Dutch artist Vincent cat Gogh never received the acclaim during his nine lives that he would achieve posthumously. He was a nomadic cat who moved from house to house and job to job, but for constancy he always had his art and his brother cat, Theo, to whom he wrote many letters describing his adventures abroad.

Cat Gogh traveled to France, and there his work began to reflect the wildlife that he encountered in the wheat fields and among the flowers. His paint palette was full of blues and golds, and he favored red and the vivid purple of his now-famous irises. He painted flowers and swirling, surreal skies along with pawtraits, self-pawtraits, still lifes, and domestic scenes.

Inspired by Arles and the French countryside, he rented a house there that came to be known as the Yellow House. He painted pictures of sunflowers to brighten up the walls and invited his friend Paw Gauguin to move into the Yellow House as the first among many artists he hoped would develop an artists' colony with him. At first, they got along well, but soon they began to cat-fight about their art. The fights got so bad that one day cat Gogh

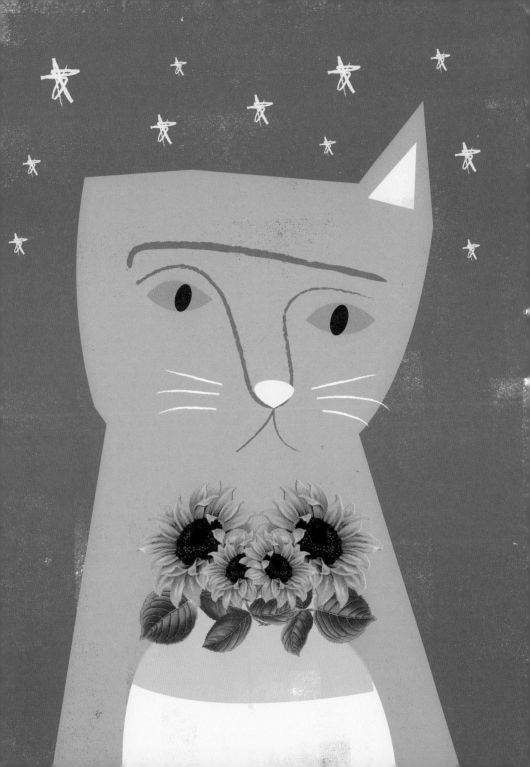

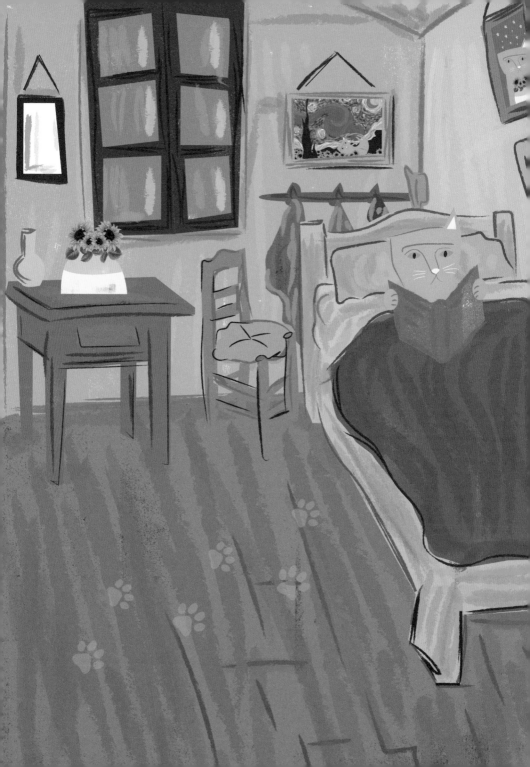

cut off part of his left ear. His ear was badly injured and Gauguin skedaddled on a train to Paris.

As cat Gogh was already a poor cat who wasn't making any scratch from his art, the loss of his ear marked the beginning of the end. He moved between psychiatric hospitals and clinics and struggled with depression. It was in the hospital that he painted *The Starry Night* while staring out his window onto the night landscape.

Although a very sad cat, he continued to paint until, only two years later, he took his life—a tragic suicide that reverberated throughout the art world that had, finally, begun to recognize his talent.

Vincent cat Gogh created more than two thousand pieces of Post-Impressionist work, each of which is now worth millions of dollars. A misunderstood genius during his lifetime, cat Gogh's pawsion for what he loved, and his influence on modern art movements, are widely recognized now: He is celebrated as one of cat art history's most important figures.

IMAGE LEFT INSPIRED BY:

The Bedroom in Arles, 1888

VINCENT VAN GOGH

IMAGE ON NEXT SPREAD INSPIRED BY:

The Starry Night, 1889

VINCENT VAN GOGH

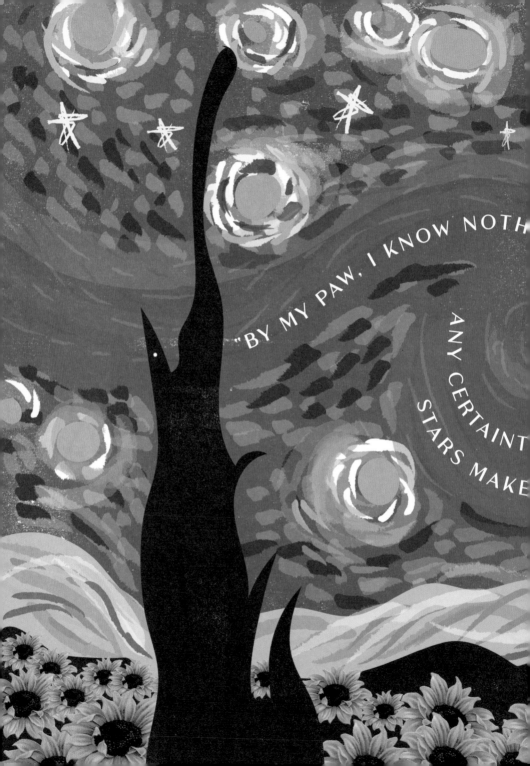

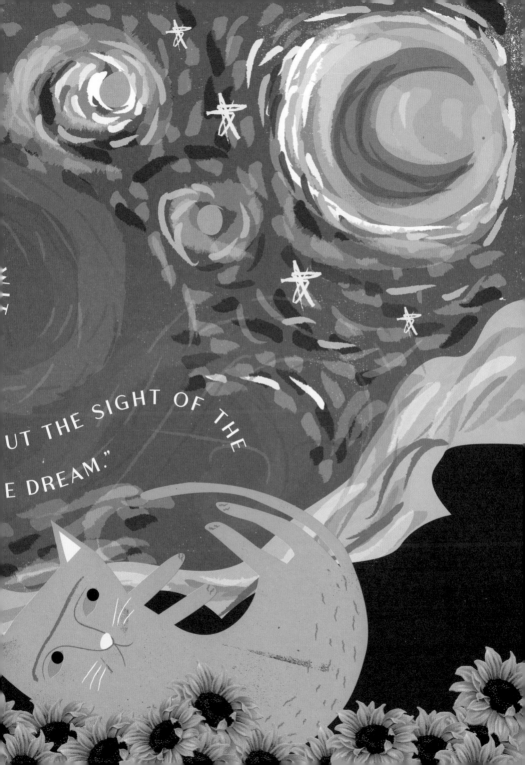

UT THE SIGHT OF THE

E DREAM."

YAYOI CATSAMA

1929–

Starting when she was a young kitten, Catsama began to see and hear things that other cats did not. Frightened of her own perceptions, or hallucinations, Catsama processed her fears and anxieties through art. To this day, she spends hours immersed in natural settings, drawing flowers and plants so close up that they look like cells or organisms. Drawing is cat-thartic for Catsama.

In her early twenties, Catsama attended art school in Kyoto, Japan, but hated the traditional master-disciple system there. She found respite in tirelessly painting pumpkins—which she regards as a source of energy—and won prizes in local art shows. Soon, however, she became frustrated by the constraints of her lifestyle and interested in European and American avant-garde art. She decided to leave Japan to seek new views, new mews, and new adventures.

Now Catsama works all over the world. Polka dots—her catnip— have become a trademark of her art. She paints dots on streets, on people, on cats and other animals, on walls, on buildings, on clothing, on the sculptures she makes in organic shapes such as

IMAGE RIGHT INSPIRED BY:

Red Pumpkin, 1992
YAYOI KUSAMA

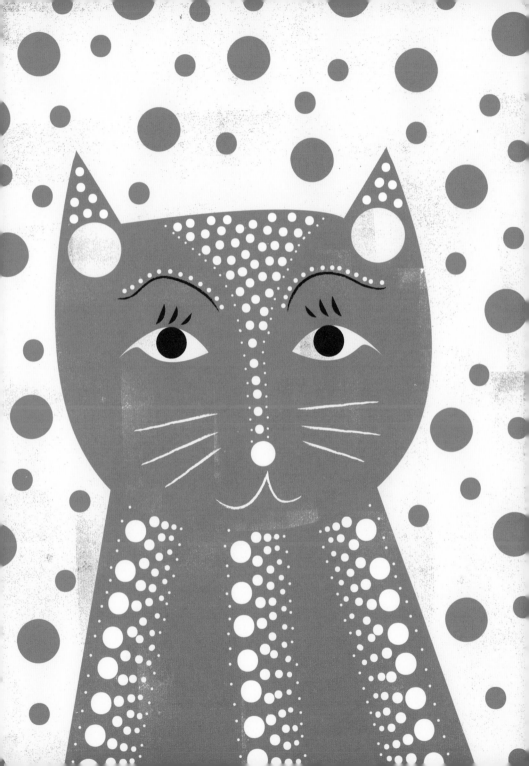

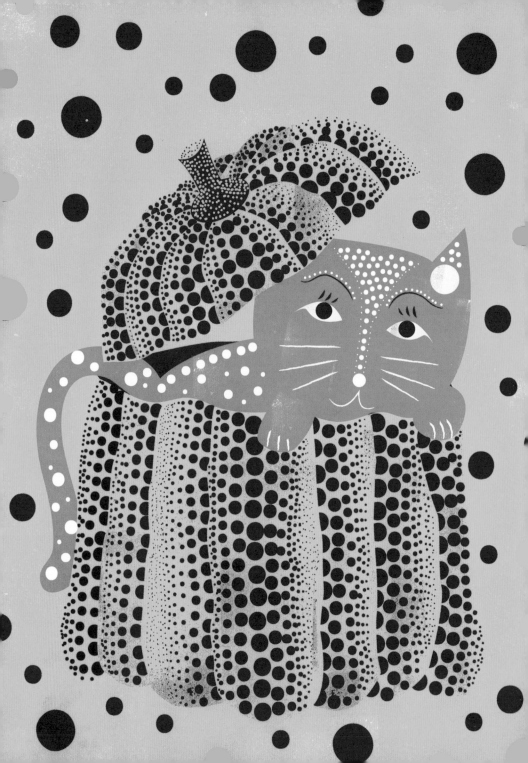